THE
BOOK OF ORNAMENTAL ALPHABETS
Ancient and Mediæval,
FROM THE EIGHTH CENTURY,
WITH NUMERALS.
INCLUDING
Gothic; Church Text, Large and Small; German Arabesque; Initials for Illumination,
MONOGRAMS, CROSSES, &c.
FOR THE USE OF
ARCHITECTURAL AND ENGINEERING DRAUGHTSMEN, MASONS, DECORATIVE PAINTERS, LITHOGRAPHERS, ENGRAVERS, CARVERS, &c. &c.

COLLECTED AND ENGRAVED BY F. DELAMOTTE.

FOURTH EDITION.

LONDON: E. & F. N. SPON, 16, BUCKLERSBURY.
1862.

PREFACE.

As there are no works of Ancient Alphabets of any excellence published in a cheap form, I have been induced, after many years' study and research in my profession as a Draughtsman and Engraver, to offer this collection to the favourable notice of the public, trusting that its very moderate price and general usefulness will be a sufficient apology for the undertaking.

The demand for a Fourth Edition within so short a period of the publication of the Third, has convinced me in the most agreeable manner that it has been a work required by the public. To render it still more worthy of their attention, I have here introduced some additions, likely to enhance the interest and increase the value of the pages, as an indication of the esteem which I have held the encouragement, and the respect I have paid to the suggestions of the purchasers of this book, and the critics by whom it has been so liberally reviewed.

INDEX.

	PAGE
8TH CENTURY. VATICAN	1
8TH CENTURY. BRITISH MUSEUM	2
8TH AND 9TH CENTURIES. ANGLO-SAXON	3
9TH CENTURY. FROM AN ANGLO-SAXON MS. BATTEL ABBEY	4
FROM MS. LIBRARY OF MINERVA, ROME	5
10TH CENTURY. BRITISH MUSEUM	6
11TH CENTURY AND NUMERALS	7
12TH CENTURY. FROM THE MAZARIN BIBLE	8
12TH CENTURY. TWO SMALL. BRITISH MUSEUM	9
12TH CENTURY. BRITISH MUSEUM	10
12TH CENTURY. BODLEIAN LIBRARY	11
13TH CENTURY. HENRY III. WESTMINSTER ABBEY.	12
13TH CENTURY. FROM LATIN MS.	13
13TH CENTURY. MS.	14
14TH CENTURY. DATE ABOUT 1340	15
14TH CENTURY. BRITISH MUSEUM	16
14TH CENTURY. ILLUMINATED MS.	17
14TH CENTURY. RICHARD II. 1400. WESTMINSTER ABBEY	18
14TH CENTURY. RICHARD II. 1400. SMALL. WESTMINSTER ABBEY	19
14TH CENTURY. BRITISH MUSEUM	20
14TH CENTURY. FROM MS. MUNICH	21
14TH AND 15TH CENTURIES. TWO SMALL. BRITISH MUSEUM	22
1475. BRITISH MUSEUM	23
1480. BRITISH MUSEUM	24
1490. BRITISH MUSEUM	25
HENRY VII. WESTMINSTER ABBEY	26
15TH AND 16TH CENTURIES. GERMAN	27
15TH AND 16TH CENTURIES. GERMAN. SMALL	28
15TH AND 16TH CENTURIES. ORNAMENTAL RIBBON	29
16TH CENTURY. HENRY VIII. MS.	30
16TH CENTURY. FROM ITALIAN MS.	31
16TH CENTURY. FROM ALBERT DURER'S PRAYER BOOK. LARGE	32
16TH CENTURY. ALBERT DURER'S PRAYER BOOK	33
16TH CENTURY. VATICAN	34
16TH CENTURY. GOTHIC. MS.	35
16TH CENTURY. GOTHIC	36
16TH CENTURY. GOTHIC. MS.	37
16TH CENTURY. LARGE, SMALL, AND NUMERALS. FRENCH. MS.	38
17TH CENTURY. MS.	39
17TH CENTURY. CHURCH TEXT. MS.	40
GERMAN ARABESQUE	41
GERMAN ARABESQUE. SMALL	42
METAL ORNAMENTAL	43
INITIALS	44
INITIALS	45
15TH CENTURY	46
INITIALS	47
NUMERALS	48
NUMERALS	49
16TH CENTURY	50
16TH CENTURY	51
16TH CENTURY. FROM WOOD ENGRAVINGS	52
MONOGRAMS, CROSSES, &C.	53

(1)

8th Century. Vatican.

ABCDEFGHIK

LMNOPQRST

VUXYZ

(2)

8th Century. British Museum.

ABCDEFGHIHL
MNOPQRST
U X M

8th and 9th Centuries. Anglo-Saxon.

ABCDEFGHIJ
LMNOPQRS
TUVXS

(4)

9th Century. From an Anglo-Saxon MS. Battel Abbey.

A A B C C D E F G h h
J L M N H H O P S S
S S S T Q V Y Z Z

(5)

from MS. Library of Minerva, Rome.

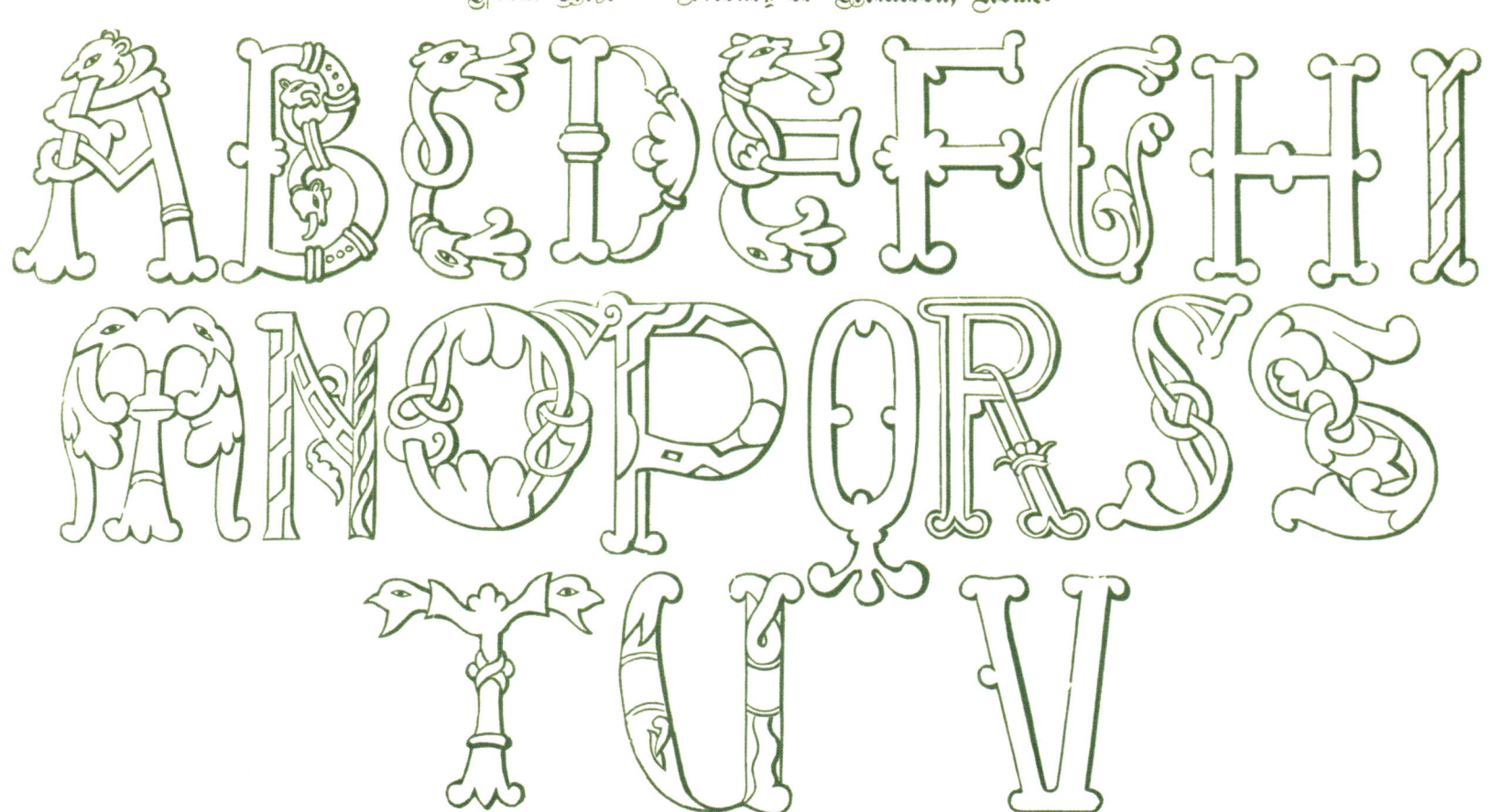

(6)

10th Century.　British Museum.

ABCDEFGHIJ
KLMNOPQRST
UVXYZ.ÆM
A??

11th Century and Numerals.

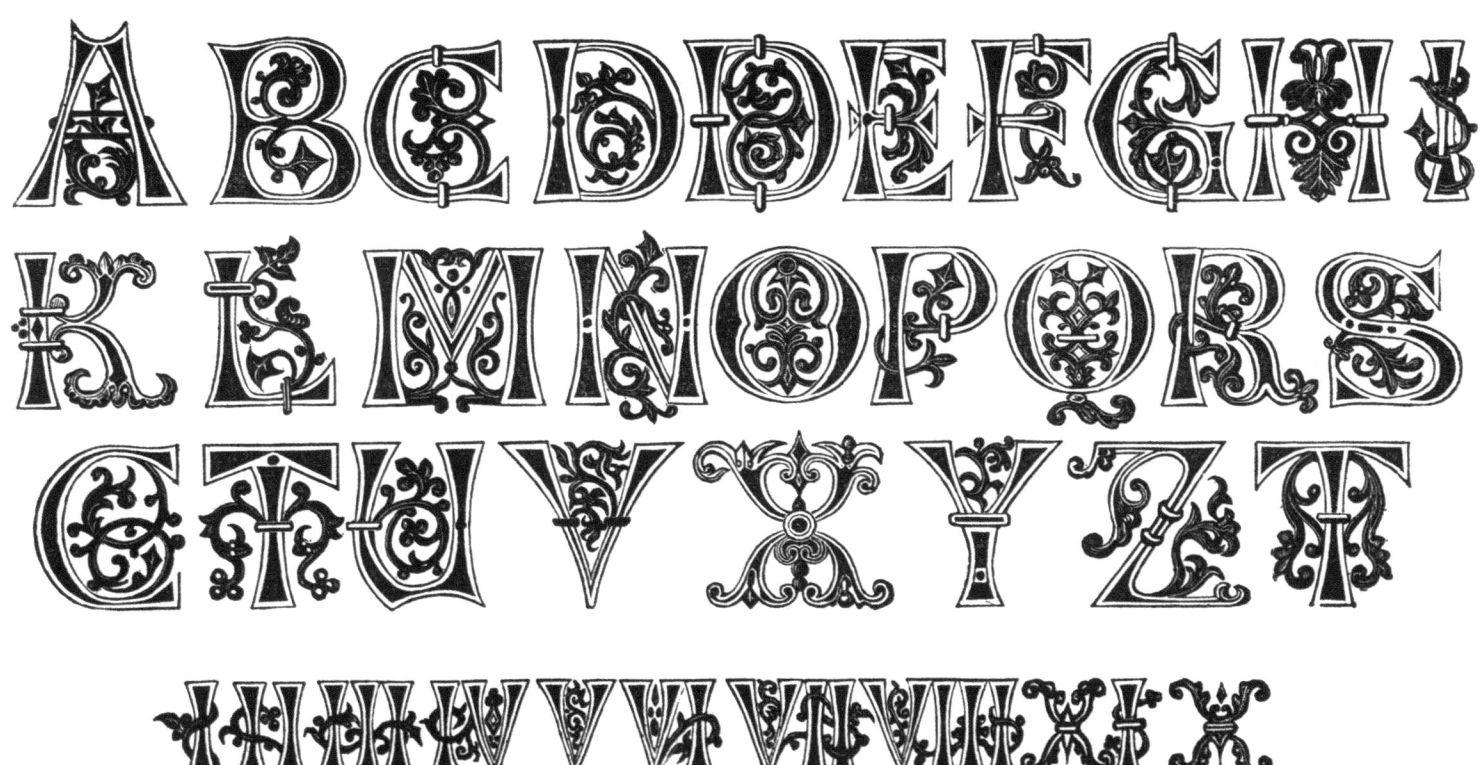

12th Century. From the Mazarin Bible.

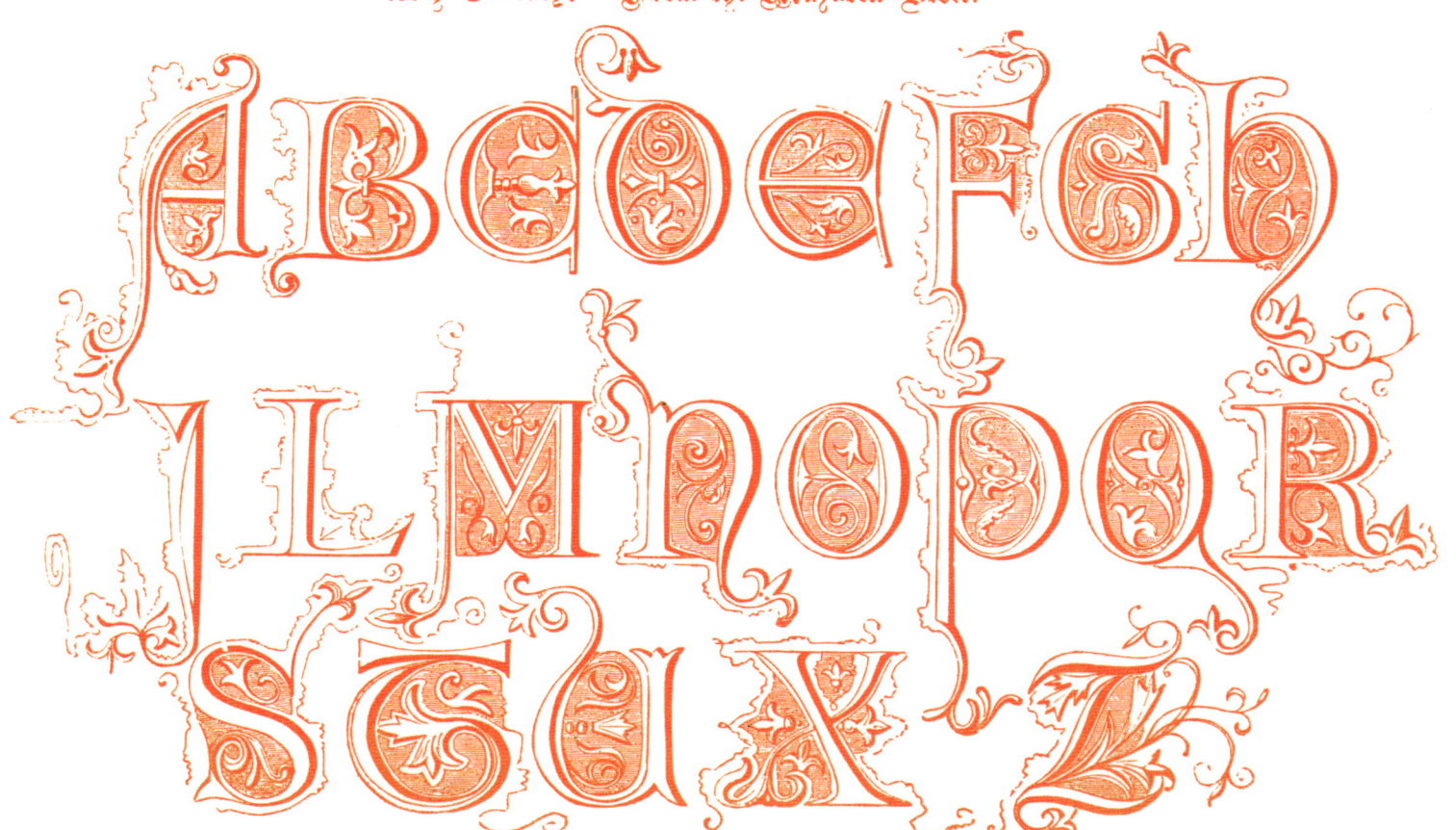

(9)

12th Century. British Museum.

abcdefghiklmnopq

rstvwryz

aabcdefghiklmnopq

rfvwxyz

12th Century. British Museum.

ABCDEFGHIJK
LMNOPQRSTU
VWXYZ

(11)

12th Century. Bodleian Library.

ABCDEFGHI
KLMNOPQRS
TUVWXYZ

(12)

13th Century. Henry the Third. Westminster Abbey.

A A M B C D E F G
H I K L M N O P Q
R S T U V W X Y Z
T O Z

13th Century. From Latin MS.

A B C D E F G H I

K L M N O P Q R S T U

V W X Y Z

13th Century. MS.

ABCDEFGHI
KLMNOPQRS
TUWXYZ

(15)

14th Century. Date about 1340.

ABCDEFGH
IHLMNOPQR
STUVWXYZ

14th Century. British Museum.

ABCDEFGHI
KLMNOPQRST
VWXYZ

(17)

14th Century. Illuminated MS.

ABCDEFGHI
KLMNOPQRS
TUVWXYZ

(18)

14th Century. Richard the Second. 1400. Westminster Abbey.

14th Century. Richard the Second. 1400. Small. Westminster Abbey.

abcdefghiklmnopqrs
tuvwxyz.

14th Century. British Museum.

ABCDEFGHI
KLMNOPQRS
TUVWXYZ

14th Century. From MS. Munich.

A B C D E F G H I

K L M N O P Q R S

T U V X Y Z

(22)

14th and 15th Centuries. Two Small. British Museum.

abcdefghiklmnop
qrstuvwxyz.

abcdefghiklmnopq
rstuvwxyz.

1475. British Museum.

ABCDEFGH
IKLMNOPQR
STUVXYZ

(24)

1480. British Museum.

A B C D E F G H
I K L M N O P Q
R S T U V X Y Z

(25)

1490. British Museum.

ABCDEFGH
IKLMNOPQ
STUXYZ

(26)

Henry the Seventh. Westminster Abbey.

A B C D E F G H I
K L M N O P Q R
S T U V W X Y Z

15th and 16th Centuries. German

ABCDEFGHIK
LMNOPQRST
UVWXYZ&

15th and 16th Centuries. German. Small.

aabcdefghijklmnopqr
stuvwxyz

15th and 16th Centuries. Ornamental Riband.

Ioannes de Yciar

16th Century. Henry the Eighth. MS.

ABCDEFGHI
KLMNOPQRS
TUVUZ

(31)

16th Century. From Italian MS.

A B C D E F G H I J
K L M N O P Q R S
T U V W X Y Z

(32)

16th Century. Albert Durer's Prayer Book. Large.

ABCDEFGH
IJKLMNOPQR
STUVWXYZ

Monogram 1553.

16th Century. Albert Durer's Prayer Book.

abcdefghiklmnopq
rsstuvwxyzzȝ

(34)

16th Century. Vatican.

ABCDEF
GHIKLMN
PQRSTU

16th Century. Gothic. MS.

A B C D E F G H I
K L M N O P Q R S
T U V W X Y Z

16th Century. Gothic.

abcd efghikl
mnopqrstuvwxyz

16th Century. Gothic. MS.

A B C D E F G H I K
L M N O P Q R S T U V
W X Y Z

16th Century. Large, Small, and Numerals. French. M.S.

A B C D E F G H I K
L M N O P Q R S T U V
1 2 3 4 5 W X Y Z . 6 7 8 9 0
a b c d e f g h i j k l m n o n q r s t u v x y z

17th Century. MS.

17th Century. Church Text MS.

A B C D E F G H I
K L M N O P Q R
S T U V W X Y Z.

German Arabesque.

(42)

German Arabesque. Small.

abcdefghijklmnopqrstuvwxyz

(43)

Metal Ornamental.

Initials.

Initials.

(46)

15th Century.

✠ ABCDEFGHK
LMNOPQRSTU

abcdefghiklmnopqr
W stuvwxyz W

(47)

Initials.

Numerals.

1 2 3 4 5 6 7 8 9 0

1 2 3 9 5 6 7 8 9 0

9th Century.

1 2 3 4 5 6 7 8 9 0

12th Century.

1 2 3 4 5 6 7 8 9 0

13th Century

1 2 3 4 5 6 7 8 9 0

14th Century.

1 2 3 4 5 6 7 8 9 0

(48)

Numerals.

12ᵗʰ CENTURY.

I·II·III·IIII·V·VI·VII·VIII·IX·X· GOTHIC.

1 2 3 D 5 6 7 8 9 0 14ᵗʰ CENTURY.

1 2 3 ℞ 6 ↑ 8 9 0 1470.

1 2 3 4 5 6 7 8 9 15ᵗʰ CENTURY.

1 2 3 4 5 6 7 8 9 0 16ᵗʰ CENTURY.

1 2 3 4 ⅝ 5 6 7 ↑ 8 9 0 1553.

1 6 1 7 1 6 7 3

(51)

16th Century.

16th Century.

(53)

15th Century. From Wood Engravings.

(54)

Monograms, Crosses, &c.

PRINTED BY C. WHITING, BEAUFORT HOUSE, STRAND.

(One of Delamotte's illuminated borders; see page iii.)

ORNAMENTAL ALPHABETS

For as long as humans have been writing we have sought ways to make our writing more distinctive, to make our words stand out and grant them greater importance and impact. This was true in medieval times, when only a tiny minority could read; it was true in Victorian age, when words were published and read more widely than ever; and it is true today, when we can access thousands of typefaces with a few clicks of the mouse. The book that you hold, that we are proud to bring back into print after a hiatus of over one hundred years, is both a celebration of this impulse and a practical resource for anyone looking for a way to make their own words, in whatever context, more distinctive. The letters, numbers, and alphabets within these pages form a curious and unique mixture, by turns graphic, romantic, authoritative, and idiosyncratic, and will undoubtedly bring something new to your work, however you choose to use them.

HOW TO USE THIS BOOK

The dates and sources that the author, F. Delamotte supplies are not entirely reliable, but that does not diminish at all from the usefulness of the book to today's artists, tattooists, illustrators, typographers, and designers. The sheer variety of letterforms on display here is an inspiration; you can pick any letter and follow how it has evolved through time. Medieval illuminators were not afraid to mix angular forms with fluid, organic shapes, and they delighted in all kinds of small illustrative adornments: people, animals, lines, patterns, swashes, and vegetation are all here. By comparison they make today's rigorous typography, and flawless digital fonts look staid and lifeless.

A type designer will find fresh forms to inspire their work, and anyone who works with letters or words in any field will be liberated by the uninhibited attitude of so many of the anonymous artists whose work we can see here. Tattooists will find here a wealth of fresh Gothic (or Fraktur) alphabets to add interest and distinctiveness to their work. Calligraphers will be able to refer to some excellent examples of their ancient art: the precision and authority of some of the lettering herein will challenge even a highly skilled expert with the pen; likewise, printmakers, carvers, sculptors, and stonemasons will find much here to draw on in their practice.

BIOGRAPHY

We know a little of the life of Freeman Gage Delamotte, who assembled the original edition of *Ornamental Alphabets Ancient & Medieval*. Born at the Royal Military College, Sandhurst, thirty miles from London, in 1814—one year before the end of the Napoleonic wars—he grew up in a United Kingdom that was flexing its imperial muscle and growing increasingly prosperous on the back of its colonial trade and dramatic growth in its domestic manufacturing.

It was this commercial and industrial growth that provided the paying audience for Delamotte's work, while the Gothic Revival was what defined the aesthetic preferences of the UK at the time. Faced with the dirty reality of a fast-changing, industrializing, modern age, architects, artists, and designers of interiors, furniture and magazines all sought refuge in the glories of the kingdom's medieval past, fondly imagined to have been a golden age of chivalry, bucolic prosperity, social stability, and religious faith.

Delamotte responded to this impulse in a variety of media: he painted, took photographs, and created illuminated manuscripts in imitation of the great calligrapher-illustrators of the medieval epoch (although unlike the anonymous monastic artists whose work he copied, Delamotte was careful always to sign his illuminations). The Metropolitan Museum in New York holds a selection of his pieces (such as the illuminated border preceding this introduction), which show the depth of his fascination with medieval illuminations of different periods—and also that his enthusiasm was not, unfortunately, matched by his skill. One biblical nativity scene with an ornate gold border is left unfinished, presumably because Delamotte's inept calligraphy crashes out of the borders of its designated space. The viewer imagines a

moment of intense frustration as Delamotte was forced to abandon his design. One wonders why, when he had spent so long on the border and the meticulously painted main illustration, he did not also put time into planning his letters.

His eye, then, was better than his hand: but it was his deep love of medieval letterforms that became his lasting contribution to the glories of Victorian art and design. *Ornamental Alphabets* was his first publication, and came out in 1858. It was an immediate success, and was on its fifth edition by the time Delamotte died four years later, at the age of forty-six. Demand for his visual expertise was clearly high, and he followed it with several other volumes of visual motifs. Leaving his second wife Caroline, three daughters and one son behind him, Delamotte died in his studio on London's Strand on July 16, 1862. His work, though, lived on after him: *Ornamental Alphabets* was in print for the rest of the nineteenth century, and had a profound influence on the Victorian visual sensibility. Now, in the twenty-first century, interest in historical letterforms and the history of type has never been higher, and this classic work deserves to be studied and enjoyed by anyone interested in calligraphy, type design, typography, manuscripts, or the joy of letterforms.

GLOSSARY

For clarity, and where it is possible to be certain which of the alphabets were originally hand-drawn (manuscript) and which printed, we have used a few specialist terms, broadly defined below. Note, though, that all of the handwriting styles mentioned here were in use for centuries across Europe; consequently they varied widely, and often drew elements from each other.

GOTHIC SCRIPT (also TEXTURA, TEXTUALIS, FRAKTUR, BLACK LETTER)

Originally a calligraphic manuscript style, this distinctive family of scripts and typefaces evolved in the mid-twelfth century in northern France and the Low Countries, and spread across Western Europe. Unlike UNCIAL alphabets, the Gothic hands have both MINUSCULE and MAJUSCULE forms (and therefore the typefaces that were derived, like Gutenberg's, from them have both upper and lower cases). Variants of the basic forms, distinguished by sharp, angular strokes and poor legibility, have been in use ever since: today they are hugely popular in tattoo design, and tattooists will find many interesting variants in these pages.

INITIAL CAPITAL

The prominent single letter that opened a page or paragraph in a manuscript, and which could fill a page in its own right. These were very often painted by a specialist, not the calligrapher or scribe who wrote most of the text. Early printed books often had hand-painted initial capitals (or "rubrics") opening paragraphs or sentences.

INSULAR SCRIPT
A version of UNCIAL script that evolved in Ireland around the seventh century and was spread by Irish missionaries to the rest of Europe over the subsequent two hundred years. Distinguished by rounded, legible forms, it has survived to the present day, and is often used in the quotes that decorate Irish theme bars.

MAJUSCULE
in manuscript (hand-written) forms, equivalent to upper case: A, B, C, and so on. In some contexts, synonymous with "capital."

MINUSCULE
in manuscript equivalent to lower case; for example, a, b, c.

UNCIAL SCRIPT
With no MINUSCULE forms, this family of scripts evolved out of the hand writing of the Roman Empire, and was in use across Europe, in many different forms, until about the eighth century.

1. 8th Century. Vatican.
A looser version of the Roman square capitals that are better known to us today, rustic majuscules were used for running text in manuscripts, but were superseded by uncial script. Rustic script would never have been carved into wood or stone, and only a few manuscripts survive. Note the open A without bar, and the absence of the letters j and w, which are not used in Latin.

2. 8th Century. British Museum.
These insular letterforms derived from illuminations and lettering in the Lindisfarne Gospels. Made around the year 700, and on display at London's British Museum from 1753, the Lindisfarne Gospels manuscript is one of the earliest great works of art from the British Isles to have survived, and were held only a short walk north from Delamotte's studio on the Strand. These letterforms are derived from the initial majuscule letters that often dominate an entire page of the manuscript.

3. 8th and 9th Centuries. Anglo-Saxon.
A selection of insular letterforms from different Anglo-Saxon manuscripts, used for the ornate initial capitals that opened a text. Bird and animal heads appear for the first time as terminals, allowing the illuminators to add life and humor to their texts, and there is an idiosyncratic mixture of angular (F) and fluid (M) forms that lend this page vitality.

4. 9th Century. From an Anglo-Saxon MS. Battel Abbey.
Battel (or Battle) Abbey was founded in 1071 by William the Conqueror on the site of his victory over England's King Harald. It had a library, of which 24 volumes are known to survive: ten are in the British Library and would have been accessible to Delamotte.

5. From MS. Library of Minerva, Rome.
There is no library of Minerva in Rome, but it seems likely that Delamotte is referring to the Biblioteca Casanatense. Known in English as the Casanata Library, this is in Rome, and is associated with the Convent of Santa Maria sopra Minerva, one of the leading institutions of the Dominican Order of the Roman Catholic church. It holds a collection of thousands of manuscripts. Note in particular the A, which seems to devour itself, an alphabetical ouroboros.

6. 10th Century. British Museum.
The sources of these letters are unknown and given Delamotte's occasional unreliability (see both the preceding and following entries) we should perhaps not rely on his dating here. The Celtic-derived line ornament on the terminals of eight of the letterforms are attractive, however.

7. 11th Century and Numerals.
The formal consistency, anachronistically even line weight, and uniformity of ornament seen here are typical of typefaces rather than manuscript alphabets. Given the vague attribution, it seems unfortunately possible that Delamotte was cheating here, and giving a much later typeface the description of a medieval hand.

8. 12th Century. From the Mazarin Bible.
Today better known as the Gutenberg Bible, this was the first substantial printed work in Europe. The best-known extant copy of the modern era was kept at the Bibliothèque Mazarine in Paris, hence the alternative name given here. Delamotte would have been able to see the copy that Thomas Grenville, one of the era's most distinguished bibliophiles, had bequeathed to the British Museum in 1846. The alphabet here is composed of ornamental initial capitals, which would have been used alone to open sections of text, but not for whole words. It is not known why Delamotte places this alphabet in the twelfth century: Gutenberg printed his bibles in the 1450s, so the dating is three centuries out.

9. 12th Century. British Museum.
Any calligrapher or hand-letterer will recognize the skill that the first of these two alphabets exhibits: the combination of confident stroke, elegant letterform, and dramatic contrast in the stroke width makes this a hand well worth emulating. Much less interesting is the second alphabet, which is possibly a later pastiche and is graceless by comparison. Source manuscripts are unknown.

10. 12th Century. British Museum.
The source manuscript for this is unknown although there is no reason to doubt Delamotte's dating. Unusually for his earlier selections, it has a full set of 26 letters, which implies that the source manuscript was written in English. Note the distinctive curled serifs, which give this alphabet an informal charm.

11. 12th Century. Bodleian Library.
The Bodleian was founded in 1602, and has been the leading library of Oxford University ever since, with a large collection of manuscripts and early printed books. A highlight of this alphabet is the graceful whip of the letter K's loop; another is the lively curlicue jumping from the top of the S.

12. 13th Century. Henry III. Westminster Abbey.
A short walk along Whitehall from Delamotte's London home lies Westminster Abbey, the source of several of the alphabets in this selection. Henry III died in 1272 but his tomb was not completed for another nineteen years. The lettering is taken from the inscription around the edge of the

tomb, which was written in French, at that time the language of England's ruling classes. More solid and regular than the preceding alphabet, these dignified letterforms are occasionally enlivened with leaf motifs on the terminals and serifs.

13. 13th Century. From Latin MS.
A set of capitals that may best be described as "eccentric," these outlined letterforms appear to be simplified versions of more ornate originals, which would have been colored in (or possibly gilded). The openings (or counters) are divided into cells, reminiscent of stained glass windows, which may well have carried decoration, characters, or color.

14. 13th Century. MS.
Another selection that Delamotte's vagueness makes impossible to firmly attribute; the irregularity of the strokes, however, confirm that it is not a later printed imitation, and the letterforms are consistent with his thirteenth century dating. Note the unusual F.

15. 14th Century. Date about 1340.
There is no reason to doubt Delamotte's unusually precise dating, which would make this script contemporaneous with the birth of Geoffrey Chaucer, author of *The Canterbury Tales*. These inky, fluid forms have a ghostly feel; note the connected serifs across the top of the W.

16. 14th Century. British Museum.
Another fine set of majuscule letters: note the tail of the Q, which seems to anticipate the flourishes of art nouveau, the decorative art style that flourished in the last decades of the nineteenth century, and the three varieties of M.

17. 14th Century. Illuminated MS.
Although these letterforms are, in themselves, unremarkable, Delamotte places them against a gracefully atmospheric bed of delicate tracery.

18. 14th Century. Richard II. 1400. Westminster Abbey.
Back to Westminster Abbey, where Delamotte again draws on a royal tomb. This time the inscription (in gilt bronze) and the majuscule lettering is clearly calligraphic in inspiration—varying stroke widths imitating the action of a quill's nib on parchment. The letterforms are elaborate (some, to modern eyes, very unclear) and show a clear Gothic influence.

19. 14th Century. Richard II. 1400. Small. Westminster Abbey.
The minuscule companion to the previous entry, this set clearly illustrates the formal and graphic qualities of a well-drawn Gothic Textura Precissa alphabet. Originating in France and the Low Countries in the twelfth century, Gothic

letterforms spread across Western Europe and displaced the much more rounded uncial and insular forms that had ruled scriptoria since the decline of the Roman Empire. A variant of this Gothic script was used by Gutenberg as a model for the first European typeface, and (unlike earlier minuscule scripts) Gothic hands have continued in use to the present day, carrying with them associations of antiquity, formality, and prestige.

20. 14th Century. British Museum.

A total contrast to the preceding script, these fluid letterforms' lively curves give them an informal air. Note the oblique counters of the B, and the Z in two parts.

21. 14th Century. From MS. Munich.

Although Delamotte claims a German origin for this very fine hand, it lacks the letters J and W and was therefore probably not from a German-language text. The unusually strong diagonals give these letters movement without detracting from their clarity; so too does the ornament to the left side of the vertical strokes on the C, D, E, and so on.

22. 14th and 15th Centuries. Two Small. British Museum.

A pair of idiosyncratic Gothic minuscule alphabets: the first, in outline, may originally have been carved. The second is distinctive for the uniformity of its stroke widths: this is not a calligraphic hand, in which line weight varies depending on the direction of the pen's movement. It is surprisingly effective and carries a couple of nice flourishes—note the curls off the top of the v and w.

23. 1475. British Museum.

Possibly derived from the text of a manuscript known as "Arundel 59," acquired by the British Museum in 1831, these are pleasing majuscule letters. Note the upbeat B, the ornament to the bar of the G, and the open P.

24. 1480. British Museum.

This set is possibly derived from "Royal 15 E i," an illuminated history created in Bruges in 1479–80, and written in French. This manuscript was owned by the English crown from the time of its creation (it was bought by Edward IV), and came to the British Museum in 1757. (The British Library, where this manuscript is now held, was not formed until 1973: the British Museum's manuscript holdings were transferred to it.)

25. 1490. British Museum.

One of the highlights of Delamotte's selection, this alphabet combines a regularity of letterform with lush, detailed ornament, and marks the first appearance of the modern uppercase N. The form of these letters suggests that

the date Delamotte proposes is out by a century or two, though: these recall ornamental type of the eighteenth century, derived (indirectly) from the capitals of the Roman Empire.

26. Henry VII. Westminster Abbey.

Henry VII reigned for twenty-four years after seizing the crown from Richard III at the Battle of Bosworth, and left England politically and economically stable—a rare achievement in the medieval period. His tomb at Westminster Abbey is particularly ornate, and carries several long inscriptions in metalwork.

27. 15th and 16th Centuries. German.

This Gothic hand is interesting for its inclusion of two ampersands that we recognise today. The first is the older form, dating back to the 800s: the second, which would develop into the italic ampersand of many modern serif typefaces, was still developing at this much later date, as this example clearly shows. Apart from that, the letters combine a calligraphic fluidity with the Gothic's characteristic solidity.

28. 15th and 16th Centuries. German. Small.

A natural companion to the preceding capital letters, this Gothic alphabet is a typical example of the family that came to dominate European scriptoria in the period before printing. Note the tail to the j and the two forms of a.

29. 15th and 16th Centuries. Ornamental Riband.

Delamotte teases us here by including the name Ioannes de Yciar, indicating that this alphabet derives from his work. Juan de Yciar (to give him the name he used himself) was a distinguished mathematician and calligrapher who lived in Spain in the 1500s and published more than one influential book on the subject of calligraphy and "writing perfectly." However, de Yciar's work consists of wonderfully lucid and graceful renaissance alphabets (derived from the Latin) and a practical, legible hand for everyday use. Neither bears any resemblance to this graceless Victorian confection, a tasteless and overwrought scrollwork alphabet that, strictly speaking, has no place in this volume. It's unclear why Delamotte included it, or de Yciar's name.

30. 16th Century. Henry VIII. MS.

Several features of these letters, notably the angular A and M, suggest a much earlier creation than the reign of Henry VIII (1509–47), and these letters have little in common with those in contemporary manuscripts that we know to be connected to him (for instance, the *Royal Choirbook*, or his *Book of Hours*). They are, however, distinctive, and the stripe and chevron motifs tie the set together well.

31. 16th Century. From Italian MS.
It is likely that these florid, fluid letters would have been painted in bright red or blue, and been surrounded by illuminated scenes. Delamotte's attribution is too imprecise to allow for identification, but this takes nothing away from the elegance and originality of the script.

32. 16th Century. From Albert Durer's Prayer Book. Large.
These are well-formed Gothic capitals, but unfortunately they are not the same as the wonderfully innovative face that Delamotte's caption implies they are. In around 1512, the German artist Albrecht Dürer (whose name Delamotte anglicises) was commissioned to supply marginal illustrations to the prayer book of the Holy Roman Emperor Maximillian. He was not responsible for the type therein, which is recognizably different to this example, and far more elegant. So once again Delamotte's attributions are unreliable.

33. 16th Century. Albert Durer's Prayer Book.
In the 1520s, Dürer published four books on geometry and measurement, and in the fourth of these he described in practical detail how to draw an uppercase Roman alphabet, and a lowercase Gothic one. Evidently Delamotte did not have access to that, or used it badly, for the irregularity of the alphabet shown here compares very poorly to the rigorous yet elegant a–z that Dürer shows his readers how to create. This is, however, a good example of sixteenth-century Gothic as it was probably more often written by those without Dürer's gifts.

34. 16th Century. Vatican.
The Vatican library contained tens of thousands of manuscripts in the period of Delamotte's compilations, and it is impossible to trace this beautiful set of knot-ornamented letters to a definite source.

35. 16th Century. Gothic. MS.
A comparison of this with entries numbered 21, 27, and 32 herein demonstrates that the basic forms of Gothic script could be endlessly varied and personalized. This is yet another fine example of the family.

36. 16th Century. Gothic.
A set which unusually combines long curlicues with the basic forms of Gothic minuscule. It is uncertain if it is authentic, but it remains a distinctive collection.

37. 16th Century. Gothic. MS.
Yet another variation on the Gothic theme, this time dense, full of right angles, and graphic in a surprisingly modern way: look at the angular, confident Z.

38. 16th Century. Large, Small and Numerals. French. MS.
Slight irregularities in the minuscule hand do not prevent this from being one of the clearest and most legible scripts in the collection. The lively double-x form of the X is a delight, and on the whole this hand is as elegant as it is practical.

39. 17th Century. MS.
A wonderful set of curvaceous, calligraphic capitals that sacrifice legibility for flow and romanticism. Use this lively alphabet sparingly, and in contexts where its letterforms will shine and not confuse. Note the variant forms of the letters S and Z.

40. 17th Century. Church Text. MS.
The source of this alphabet is unknown, but it is a wonderful example of a rigorous late-Gothic or Fraktur hand. These majuscule letters would never have been used to spell out a full word, and should be combined with a minuscule Gothic (for instance, entry 46 of the present book). Calligraphers and letters will find emulating this confident, detailed hand a considerable challenge.

41. German Arabesque.
The term "Arabesque" in this context refers not to any actual Arabic influence on the letterforms, but to ornamental use of floral or geometric patterns. These examples are in fact neither ancient nor medieval, but derived from a nineteenth-century display typeface.

42. German Arabesque. Small.
The lower case to match the preceding alphabet. Note that, unlike a genuinely medieval alphabet, it includes a complete set of 26 letters—including the j and w that are usually omitted. Its German origins are betrayed by the inclusion of the "long s" form alongside the short s. This could be used in combination with a z to form the German letter ß or Eszett.

43. Metal Ornamental.
The regularity of this alphabet and its ornament strongly suggest a post-medieval origin. Note that the S is reversed, possibly in error.

44. Initials.
A collection of letters with nothing connecting them but their larger size and, we assume, later-than-medieval date. These have the look of Victorian pastiches, but they also have a variety of design features that may inspire.

45. Initials.
Another incoherent set, presenting variety of form that tells us more about Victorian enthusiasm for the cod-medieval than anything else.

46. 15th Century.
The characteristic medieval combination of rounded capital letters with rigorous, calligraphic lowercase is showcased perfectly here. Note the barred form of the lower case x and the plump capital W at bottom left.

47. Initials.
Like 44 and 45, a fairly random selection, unified—if that is the right word—by dragons.

48. Numerals.
This and the following page form a short survey of the evolution of Arabic numeral forms, with one Roman numeral interpolation. Delamotte's dating of the first alphabets on this page is clearly inaccurate: Arabic numerals (which had actually originated in India but were brought to Europe by Arab scholars and traders) made no appearance in European manuscripts before the end of the ninth century, in southern Spain, and their form at that point was very different to the first three here. It seems likely that Delamotte, wishing to provide his readers with numeral forms to match the (authentic) letterforms of earlier pages, pastiched them himself.

49. Numerals.
Of particular interest is the fifteenth-century selection, which is strikingly modern to our eyes and would have been at home five centuries later. It is preceded and succeeded by vibrant calligraphic forms that today's hand letterers will enjoy.

51. 16th Century.
The regular dimensions and ornaments of these majuscule letters imply that they are initial capitals, created to be used individually. Meanwhile their precision and even line weight suggest that they are type rather than manuscript letters. In any case, the combination of strong, rounded letterforms with typographic detail (the borders) and floral ornaments makes this one of the most attractive selections in the book.

52. 16th Century.
It is a pity that this alphabet, like the previous one, is incomplete, for the selection is full of life and wit. Animals, birds, plants, and monsters bring the

(xiv)

fluid letterforms to life and make them perfect for their intended role as initial capitals. Note that Delamotte places U and V out of sequence.

53. 16th Century. From Wood Engravings

Copied from carved wood, these letters are wonderfully exuberant expressions of lowercase Gothic letterforms, capped with gracefully curved and knotted ornaments. The absence of the letters j and w suggests that the source material was in Latin, although these letterforms are wholly northern European in style.

54. Monograms, Crosses, &c.

Delamotte's selection of ornaments and Christograms perfectly epitomises the mid-Victorian conflation of ideas of Christianity, nationalism, and monarchy. The exact sources of his selection are unknown, but are characteristic of the late medieval period; the five Christograms (one reading IHC, four IHS) are abbreviations of the name "Jesus" that had been common in Latin for centuries and, by the fourteenth century, entered into use in English. Six forms of cross are set alongside the national flowers of England (the rose), Scotland (the thistle), and Wales (the daffodil), and one crown. The *fleur-de-lys* was often associated with the Virgin Mary.

The keen-eyed reader will have noted that this collection skips straight from selection 49 to selection 51 without troubling to stop at 50. This is in faithful imitation of Delamotte's original numeration. We cannot know for certain how the omission happened, but given Delamotte's evidently relaxed attitude to historical accuracy, we should probably assume that it was nothing more sinister than an editorial or printing oversight. Interestingly, later editions of the book (published in the years following his death) have this error corrected.

An Hachette UK Company
www.hachette.co.uk

First published in Great Britain in 2018 by
ILEX, a division of Octopus Publishing Group Ltd
Octopus Publishing Group
Carmelite House
50 Victoria Embankment
London, EC4Y 0DZ

www.octopusbooks.co.uk
www.octopusbooksusa.com

Design, layout, and text copyright
© Octopus Publishing Group 2018

Distributed in the US by Hachette Book Group
1290 Avenue of the Americas, 4th & 5th Floors
New York, NY 10104

Distributed in Canada by Canadian Manda Group
664 Annette St., Toronto, Ontario, Canada M6S 2C8

pp. i–xv written by Alan Anderson

Publisher: Roly Allen
Managing Editor: Frank Gallaugher
Senior Editor: Rachel Silverlight
Editor: Francesca Leung
Art Director: Julie Weir
Senior Production Manager: Peter Hunt

All rights reserved. No part of this work may be reproduced or utilized in any form or by any means, electronic or mechanical, including photocopying, recording or by any information storage and retrieval system, without the prior written permission of the publisher.

ISBN 978-1-78157-565-9

A CIP catalogue record for this book is available from the British Library

Printed and bound in China

10 9 8 7 6 5 4 3 2 1

Delamotte illuminated border courtesy of the Metropolitan Museum: The Elisha Whittelsey Collection, The Elisha Whittelsey Fund, 1966.

INITIALS FOR ILLUMINATION.

Mediæval Alphabets

AND

INITIALS FOR ILLUMINATION.

BY F. G. DELAMOTTE.

TWENTY TWO PLATES, BEAUTIFULLY PRINTED IN GOLD AND COLOURS.

Small 4to, cloth gilt, Six Shillings, post free.

E. & F. N. SPON
16, BUCKLERSBURY.
LONDON